Killers in Tutus

W ILLIAM M ARLING

Copyright © 2017 William Marling

All rights reserved.

ISBN: 153976038
ISBN-13: 978-1539769033

CONTENTS

Acknowledgments		5
1	Beirut	6
2	Writers	34
3	Americas	54
4	Europe	82
5	Personally	100

FOR RAILI

ACKNOWLEDGMENTS

To the cliff-divers of Beirut, my son Daniel, the coffee-vendor on the Corniche, Osama the veggie man, Susan and Larry Rakow, Anne Luyot, Father Tom, Kevin Oderman, Patrick McGreevy, Gaylan Nielson, Frank Erickson, Syrine Hout, Marie Lathers, Patti and Richard Lawrence, Piret and Jaan, Triin and Tarmo, the woman who gives me free coffee at PBL, my parking buddies, my swim buddies, Mom and Dad, Karen, the thousands of people who shower me with small kindnesses and saving humor on a daily basis. To all of you who exhibit the grace of living and an eye for the essence, I say thank you.

BEIRUT

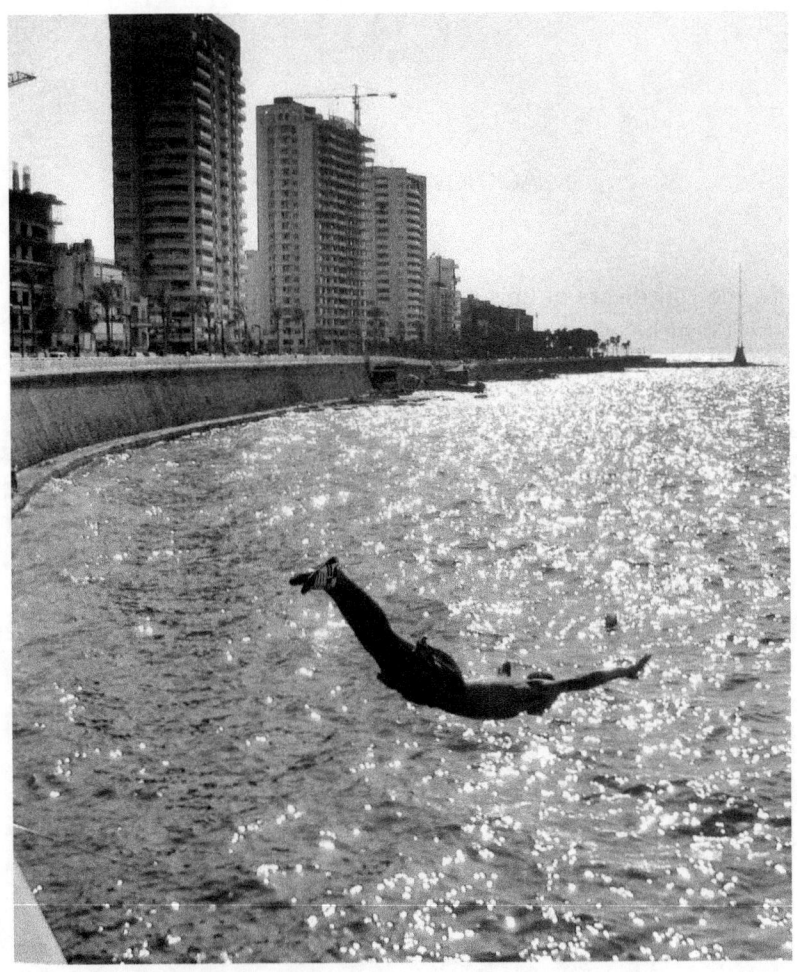

You wanted a life luminescent
as sunset over the Pacific,
as ripe as Eliot's peach,
as soft as a child's hand.

You lived a life acquiescent,
commodious as an old suit,
practiced in tomorrows,
betrayed in a child's look.

You end with a life unexpected,
not glimpsed in a rearview mirror,
not begotten, not made,
nor wishful as a child's book--

but boys with toys, killers in tutus.

Maybe you sit in azure sunshine
in San Diego or Brisbane, maybe not,
probably not in the Beirut smog
of spring's tense re-entry.
After long winter, the sun returns
like an overdue bill you forgot.
At least you have creditors eh?
Some things pulse with greenness,
a lot of them weeds or thorny.
Other things insist on death.
She looks up from her minions,
and you walk behind house or shed,
looking into that over-looked path,
behind back walls, where the orchid
discovers you looking for it.

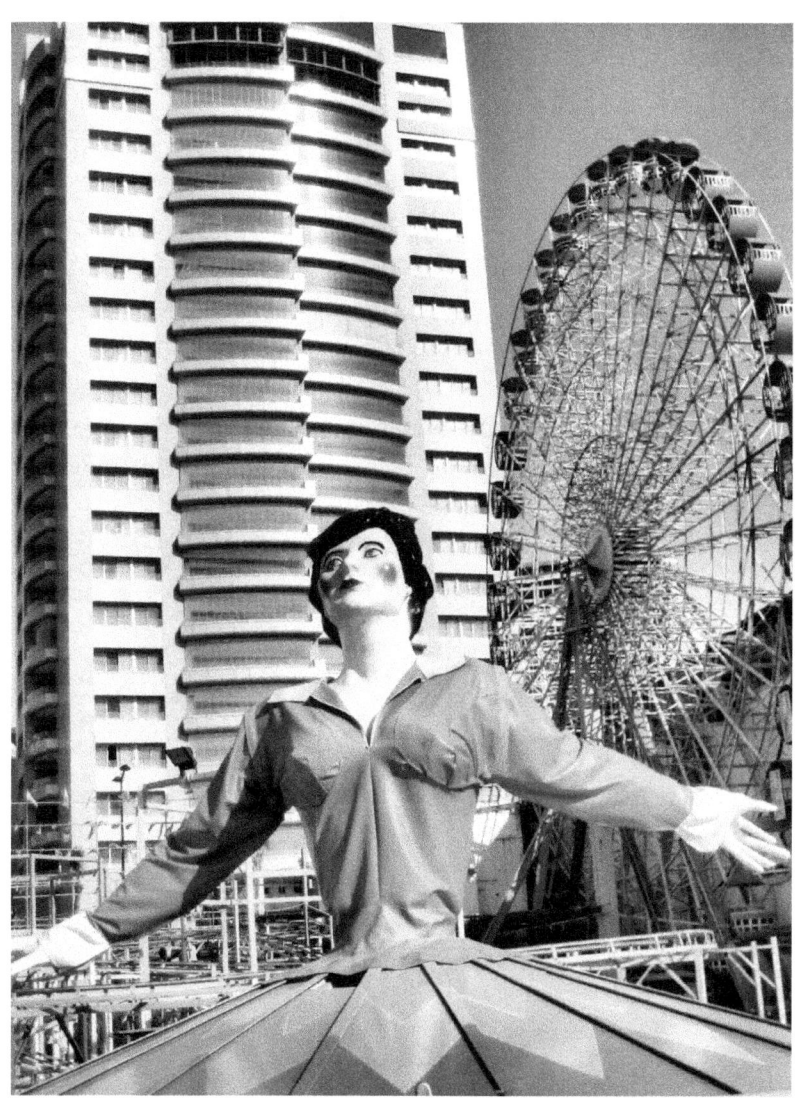

Luna Park, The Corniche, Beirut

We could only eat so much flat bread

before rising, yeasty, billowing up

the hill to an alley off Hamra Street,

to Bread Republic, by Radio Shack,

where she taught us zaatar,

toasted shards of old flatbread,

kaak, and honey from Jabal.

Tastes bloomed on her shelves.

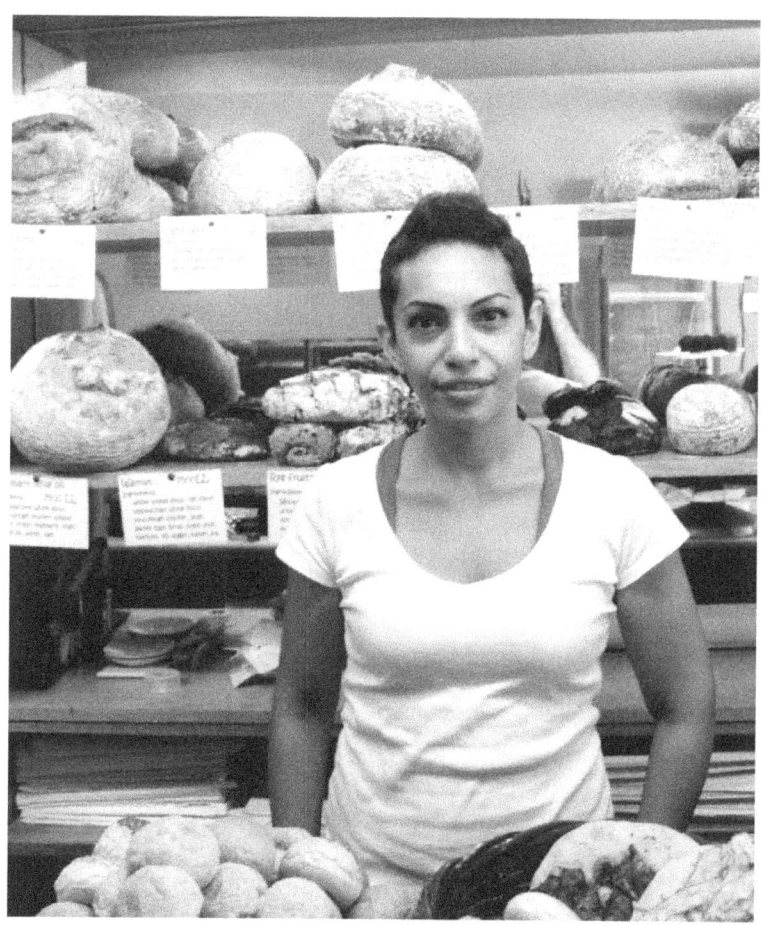

Bread Republic, Hamra Street, Beirut

That year he saved up enough
money to make the haj, so
they started to call him "Haji"
in the neighborhood. His
friends came and read the Koran
out loud as he worked, but he never
prayed, that we saw, though maybe
work was his prayer. Everyone
in the neighborhood bought from him,
the old Maronite ladies, the Filipina
and Ethiopian maids. Aside from us
the only 'Western' customers were a black guy
and a well-dressed German who filled
his briefcase with tomatoes and dates.

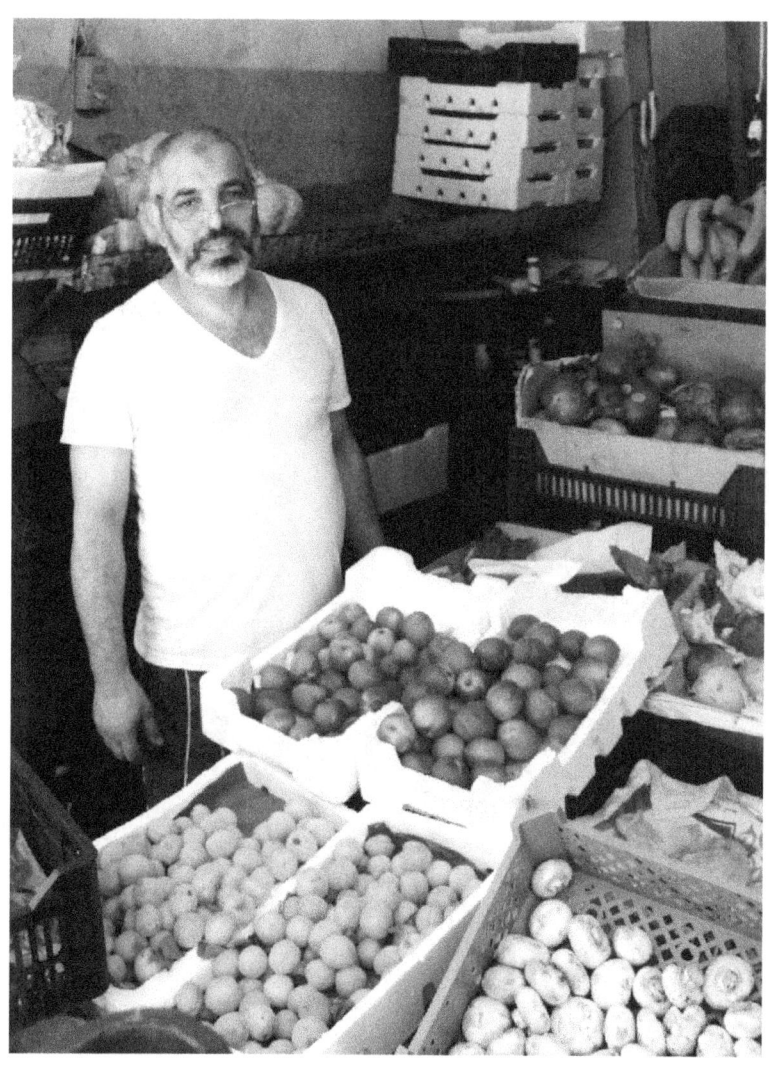

Osama, Jeanne d' Arc St., Beirut

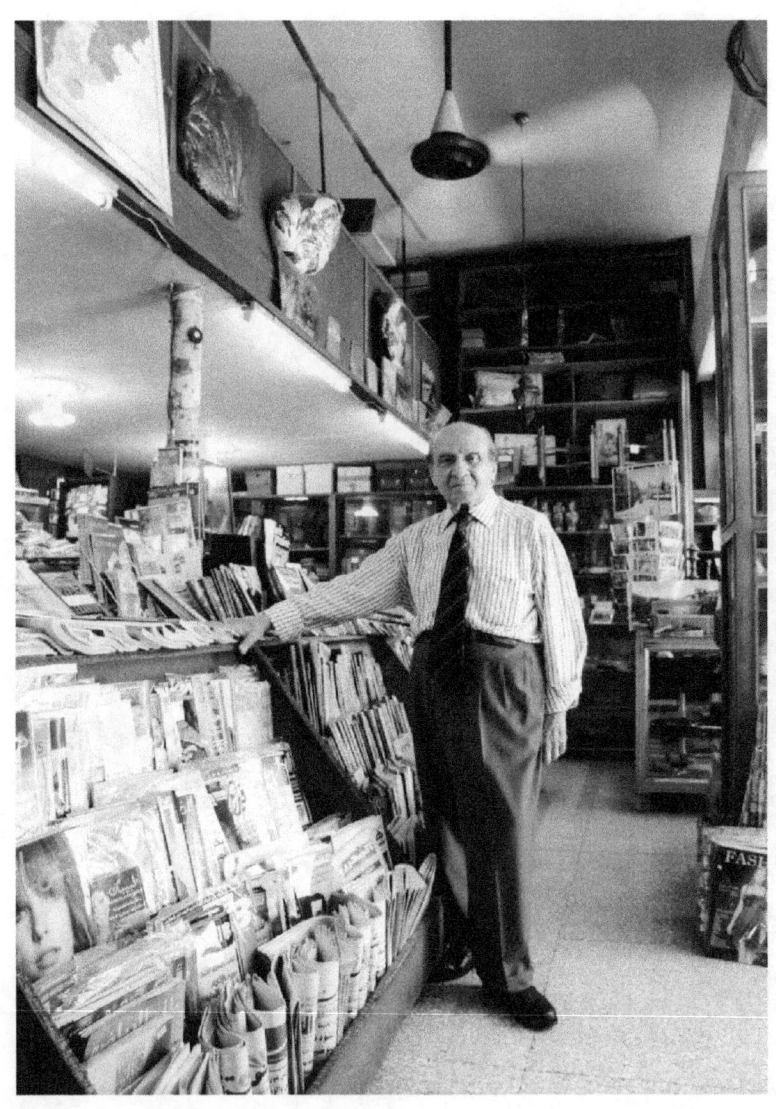

Said at Said's Bookstore, Hamra, Beirut

No, he said, I am not related to *that* Said —
there are lots of Saids in Lebanon.
And those Saids, these days,
are chiefly in the Makdisi clan. But
the way he kept shop was charming.
It was always clean, on a dusty street,
a wide variety of non-Arabic magazines,
books and postcards dating to the '70s.
He let everyone browse for 15 minutes,
then came over to ask if he could help.
He knew his stock, and if you asked
for something, he knew where to look.
I wanted to buy more from Said's
 but it wasn't a bargain, just more real
 than Antoine's on Hamra Street. But
in Beirut, real is who you are related to.

On every visit we practiced
a bit of French, a ritual.
She would give me a cookie,
as if I had been a good boy
and if I bought enough, but
I never deduced the price point.
In some other life she must
have seen a bullfight, and she
knew I wasn't a good boy.

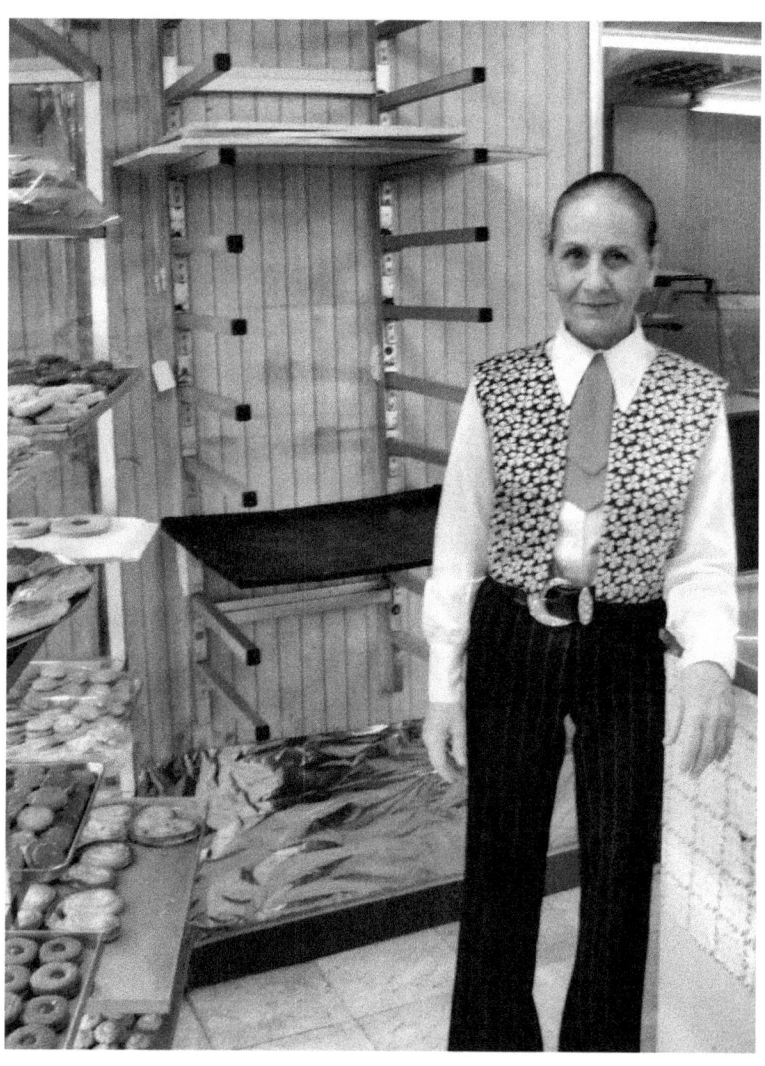

Asma Jabil, the French Bakery, Hamra

Locksmith, stationer, battery supplier,

he's the Hamra handy-man who can fix

your auto or air conditioning, he says,

and when he can't, apologetically

he charges you only two dollars.

Son of Phoenician traders who

reached Marseilles and the Black Sea

he's happy to sit in sun on stool.

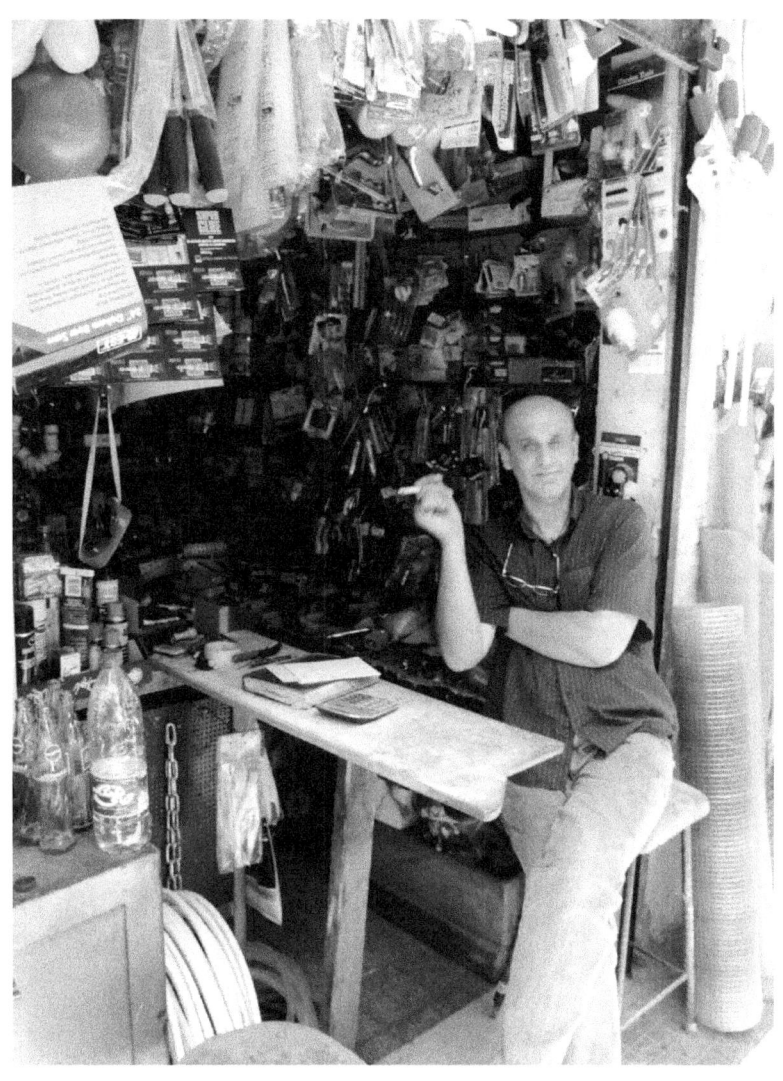

Locksmith, Jeane d'Arc St., Hamra

The handbag bread man always
said, "Wait ... a fresh one coming up--"
He pointed to the chain descending
to the ovens in his basement.
I never understood why he would
not sell me an hour old bread.
Often he made me wait ten minutes,
until the bread met his expectation.
Then he asked "zaatar? zaatar extra?"
He refused to believe that we liked
the taste of innocent bread.

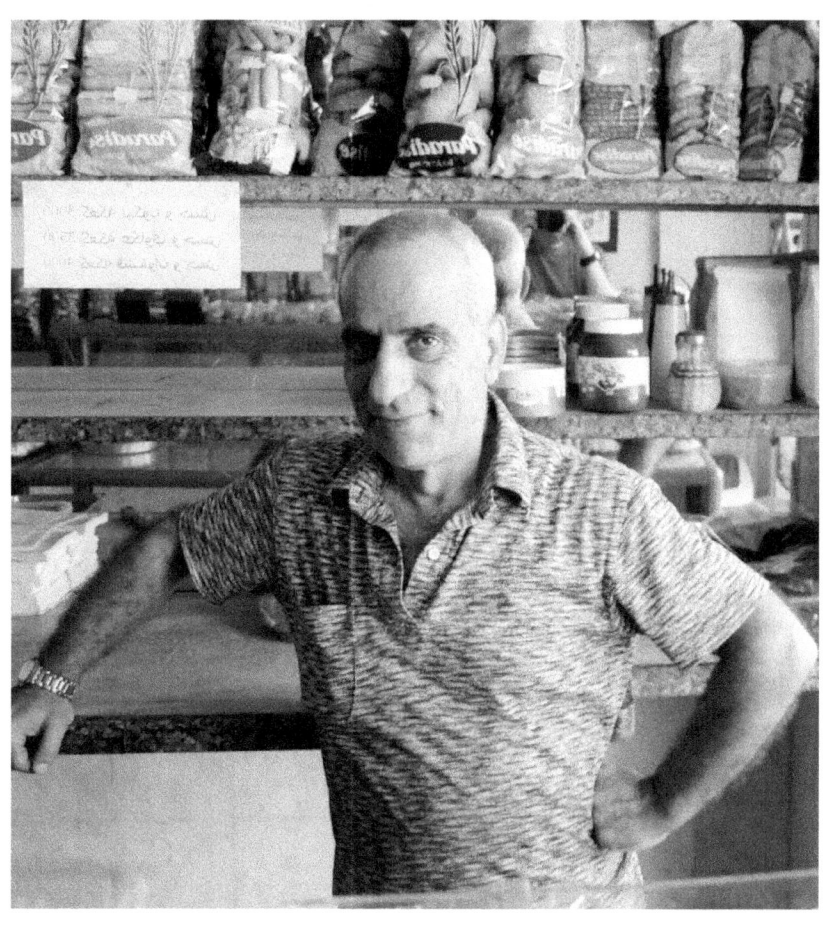

The Handbag bread man, Sidani St., Beirut

" Take me to the Hilton! "

 hard to forget the civil war

"The Places you'd rather be!"

 when the mortar

" Everything, right where you need it!."

 holes are right

 in your room.

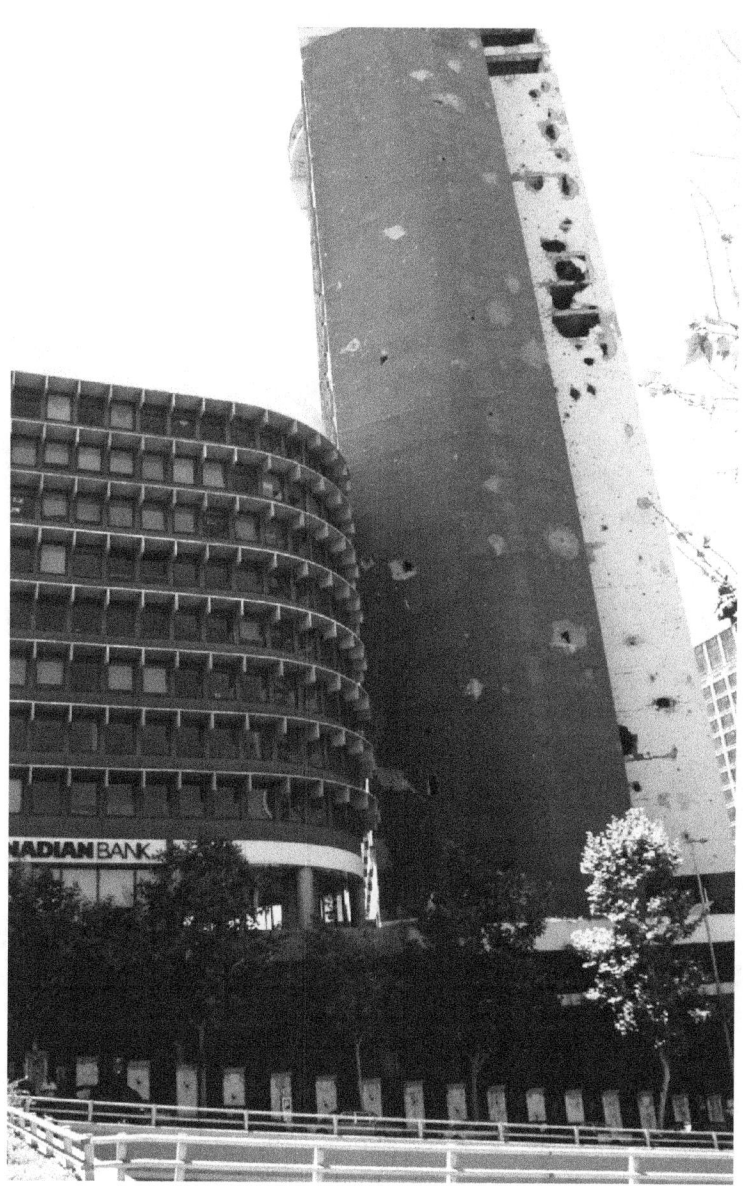

The old Hilton, Sassine St, Beirut.

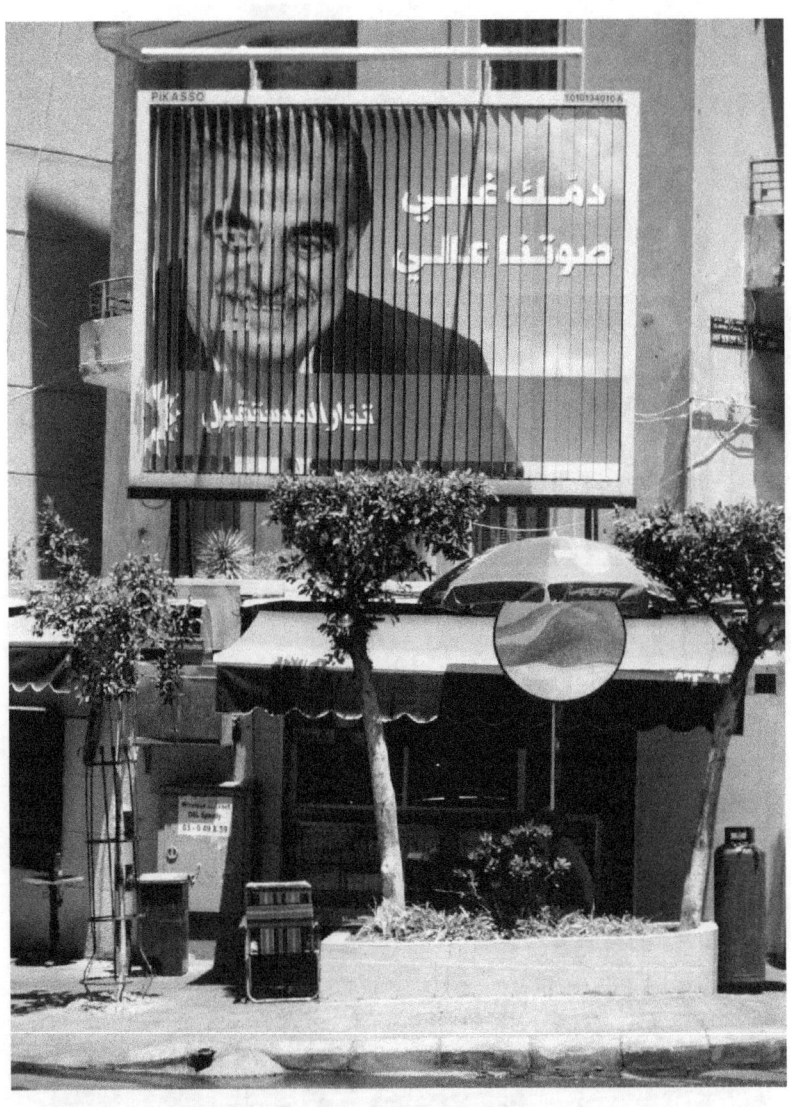

Mouawad's, Abdul-Aziz and Makdessi Sts, Beirut

THE MANOUSHI STAND

I was sitting under the billboard of the assassinated Rafic Hariri in front of Mouawad's stand — corner of Abdul Aziz and Makdessi Streets — eating one of the cheesy *man'ousheh* he serves with an angry face while glaring at the passersby.

Traffic was gridlocked, white-robed Saudis and girls in halter-tops were jay-walking through throbbing cars, but I was thinking about Madrid, 20 years ago, when that man came running downhill with the sledge hammer so fast the police had no chance to stop him. He jumped up on the hood of the parked car (it was his) and bashed in the windshield, then pivoted and bashed in the grille. A circle of spectators gathered, but the police stood aside. They were going to tow his car, with its *banderilla* of tickets, when he finished – that was Madrid 20 years ago!

What's the connection in my brain, I'm wondering? Men love their cars here—this is the capital of patched-up, repainted, duck-taped and tenderly used Mercedes-Benzes. But, violence always lurking, and the spectatorship, that must be it. One event is editing my perception of the other, an experience I have here more and more.

But before I can figure this out, a girl crosses toward us wearing gold shoes, pink tights and a Madonna bustier. Her mother on her arm wears a black burqa. All us guys stare, sitting on that white wall eating pizza. Even Mouawad stops sliding pizzas in and out of the oven. It's okay to stare like a village hick. Half of these guys are virgins, but they won't admit it. They have their arms over one another's shoulders — *habib*, you have a problem with that?

I like the Corniche
at sunset, at Ramadan,
the day's heat lifting,
cool breezes flowing
south from Turkey.
I like the seaward ones
who fish toward night
with impossibly long
poles for tiny flashing
fish and sea debris,
the swimmers shouting
each to each, intimate
as day does not permit.
I love most those
with backs to the sea,
men bringing chairs
to the sea to ignore it
for a game of backgammon,
women in hijab strolling
with sisters in spandex,
the man on one crutch
who sells garlic, the Druze

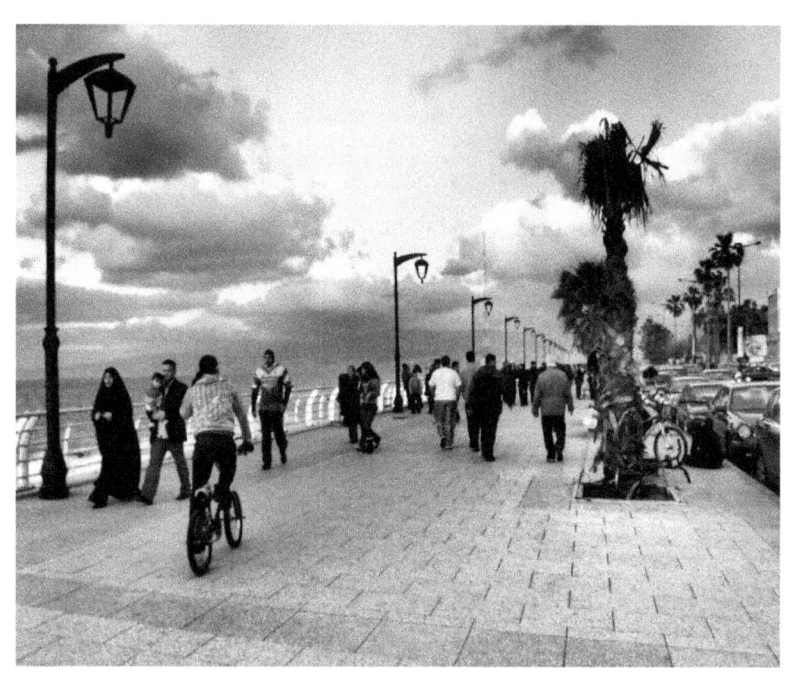

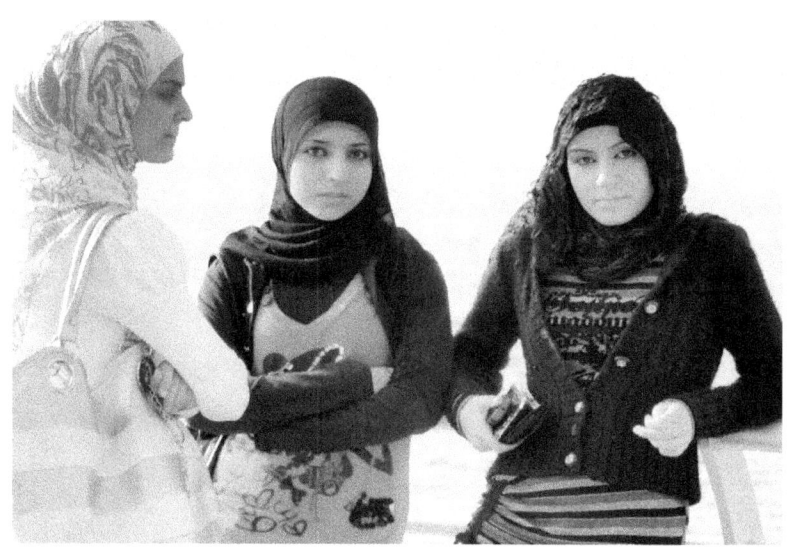

in black and white and
couples smoking *nargilah*,
the Palestinian girl,
as thin as spaghetti,
who plays badminton with
her dad over a park bench.
They bring chairs, they put
down roots, their backs to
the dark whispering sea,
they watch the 18 religions,
the 12 kinds of dates and
27 nuts of Lebanon mixing,
flowing, a *fattoush* of
Arabic and French.
Two guys, well-spaced
in parked cars, play music
that changes as you walk,
and some passersby dance.
I do, and you reading
this, *yalla*, dance!
dance against the dark!

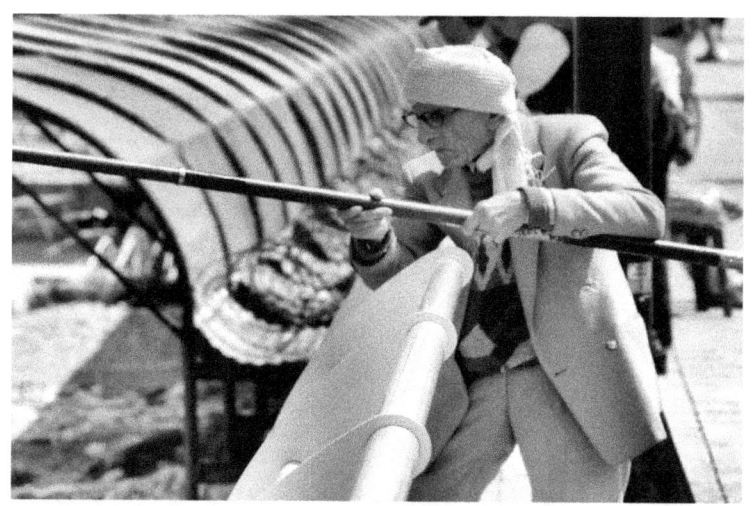

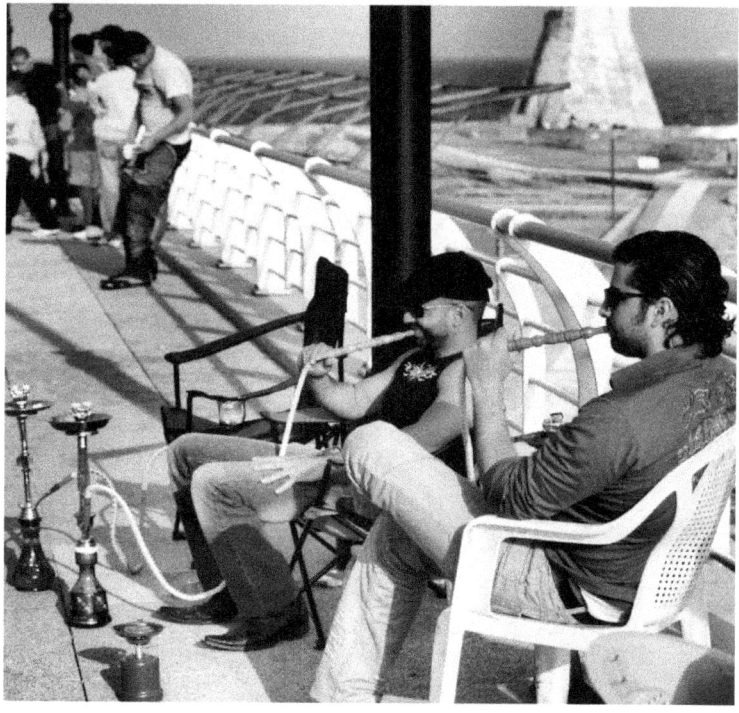

Why are you
tearing down
my party's
poster, the man
asked me.
I had only
a ragged shred
in my hand.
Because I
need to write
a poem,
I said,
to say how
all paper
peels away
from all walls.

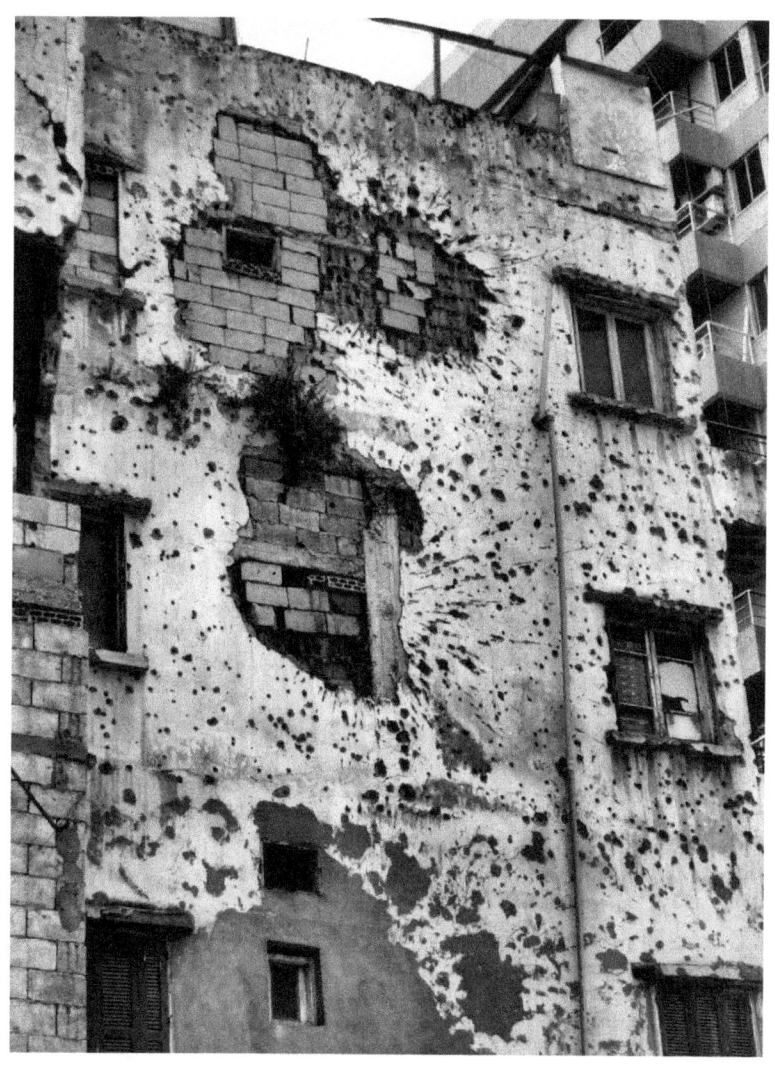

We walked back through the Palestinian

camp at Saida. Barber shops and food stores,

it seemed so normal, you wanted to say

the problem lies elsewhere, you might

feel your heart lifting , until you turned

the corner to the toy shop, where a boy

set up a pink and green machine gun.

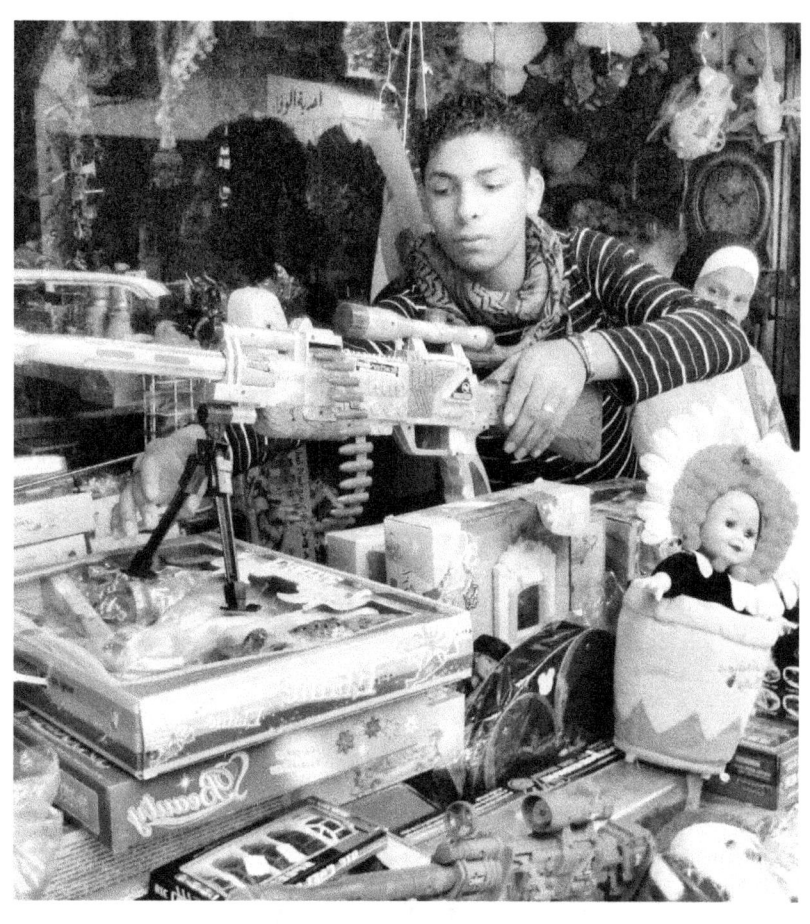

WRITERS

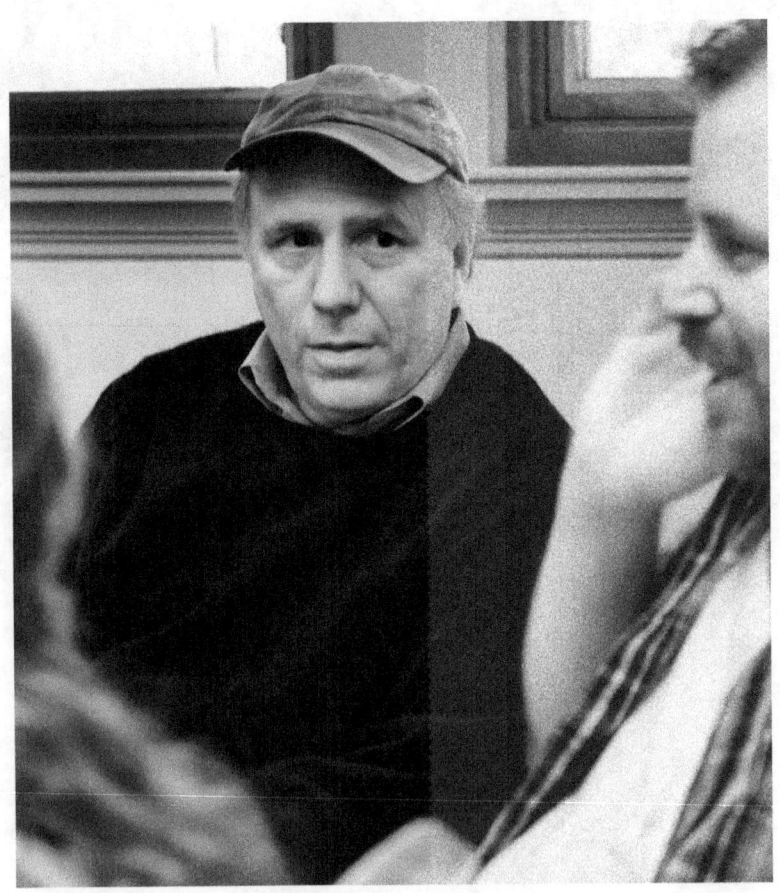

Ian Frazier, Case Western Reserve U., 2007.

"Among the cruelest tricks life plays is the way it puts the complicated part at the end, when the brain is declining into simplicity, and the simple part at the beginning, when the brain is fresh and has memory power to spare. As a boy I had only a few things to keep track of. There was one place, the small town where I lived; two pro sports, baseball and football; three TV channels; four sequential seasons, as yet unmixed by global warming; five kids in my neighborhood to play with; and so on."

Ian Frazier, "If Memory Doesn't Serve," *The Atlantic.*

"There was a time I could say no one I knew well had died. This is not to suggest no one died. When I was eight my mother became pregnant. She went to the hospital to give birth and returned without the baby. Where's the baby? we asked. Did she shrug? She was the kind of woman who liked to shrug; deep within her was an everlasting shrug. That didn't seem like a death. The years went by and people only died on television—if they weren't Black, they were wearing black or were terminally ill. Then I returned home from school one day and saw my father sitting on the steps of our home. He had a look that was unfamiliar; it was flooded, so leaking. I climbed the steps as far away from him as I could get. He was breaking or broken. Or, to be more precise, he looked to me like someone understanding his aloneness. Loneliness. His mother was dead. I'd never met her. It meant a trip back home for him. When he returned he spoke neither about the airplane nor the funeral."

Claudia Rankine, "Don't Let Me Be Lonely [There was a time]"

Claudia Rankine, at Case Western Reserve U, 2010.

"Sinatra with a cold is Picasso without paint, Ferrari without fuel—only worse. For the common cold robs Sinatra of that uninsurable jewel, his voice, cutting into the core of his confidence, and it not only affects his own psyche but also seems to cause a kind of psycho-somatic nasal drip within dozens of people who work for him, drink with him, love him, depend on him for their own welfare and stability. A Sinatra with a cold can, in a small way send vibrations through the entertainment industry and beyond as surely as a president of the United States, suddenly sick, can shake the national economy."

Gay Talese, "Frank Sinatra Has a Cold," *Esquire*.

Gay Talese, Beowulf Room, Case Western Reserve U, 2008.

"In Kenya, English became more than a language: it became the language, and all the others had to bow before it in deference. Thus one of the most humiliating experiences was to be caught speaking Gikuyu in the vicinity of the school. The culprit was given corporal punishment ...or was made to carry a metal plate around the neck with inscriptions such as I AM STUPID or I AM A DONKEY."

Ngũgĩ wa Thiong'o, *Decolonising the Mind*.

Ngũgĩ wa Thiong'o , Case Western Reserve U., 2005

Jane Kramer, Clark Chapel, Case Western Reserve U. 2009

Her prose is like a great pickle, and I was reading her posts from Europe before my brain realized, oh, this is Jane Kramer! She's a small person who takes on large topics, so I photographed her in a corner of the large classroom that we call the Chapel in Clark Hall. There I could imagine her writing, "When the writer was a girl, lost in poetry, the only root on her mind was the mandrake root in John Donne. Roots were scary, the cautionary stuff of fairy tales and folklore. Childhood habits of mind can be hard to break."

Jane Kramer, "Root Vegetables," *The New Yorker*

Mary Grimm, Guilford House, Case Western Reserve U. 2007.

"As soon as I saw my parents driving away from me where I stood in front of the dorm, I snapped out of it. The folds of my new identity draped themselves around me again—not someone's child, not someone's boring older sister. I had a life. I knew people. I knew things.

"It all came back to me: how I could go out without telling anyone, how I could stay up as late as I wanted without anyone asking me if I knew what time it was. I was just then trying to become accustomed to the idea that I was a woman. I set it as a task: I would not think of myself as a girl anymore. "Woman," I said to myself, standing there in front of the dorm, "this is the beginning of it," and I saw no irony in the statement. "

Mary Grimm, *Stealing Time*

"Perhaps the body has its own memory system, like the invisible meridian lines those Chinese acupuncturists always talk about. Perhaps the body is unforgiving, perhaps every cell, every muscle and fragment of bone remembers each and every assault and attack. Maybe the pain of memory is encoded into our bone marrow and each remembered grievance swims in our bloodstream like a hard, black pebble. After all, the body, like God, moves in mysterious ways...

"But if this is true, surely the body also remembers each kindness, each kiss, each act of compassion? Surely this is our salvation, our only hope - that joy and love are also woven into the fabric of the body, into each sinewy muscle, into the core of each pulsating cell?"

Thrity Umrigar, *The Space Between Us.*

Thrity Umrigar, Guilford House, Case Western Reserve U., 2008.

"I liked working in the back of the store. My father made sure the bathroom detail fell to me. It was a message intended not only for me but also for everyone in the store who watched to see how the boss's son would be treated. With brush and Comet, I proudly scrubbed away the stains until the bowl and sink gleamed. I broke up boxes and piled them high in the back alley for removal. I wielded a wide broom around and under the tailor's shop and steam press, sweeping up fallen razor blades, bits of chalk, bobbins, severed cuffs, orphaned threads and discarded plastic coffee cups. It was also my chance to talk with the tailor, Remo, an Italian who always drove a new Riviera, and to steal a glimpse of his wall calendar that featured pin-ups. My father respected him and the hours he put in. Remo, my father explained, was an "immigrant," a word he uttered as if it were a title of nobility and a synonym for sacrifice."

Ted Gup, "I Watched My Dad Work," *The Washington Post*.

Ted Gup, Clark Hall, Case Western Reserve U., 2007.

Michael Clune, Nighttown, Cleveland Heights, OH, 2013.

"Dom's brother walks through the door and angrily starts hammering a light-fixture bracket into a wall. Dom and I follow. There is absolutely no furniture or wallpaper or pipes or carpet or tile anywhere to be seen in the room. Light's coming in through a single window with a sheet stapled over it. There must be forty staples in it. The brother's work. I see Dominic has a syringe sticking out of his neck. I just like to be around him. Things happen around him. He's like an open door things walk into and out of. Some of the things stay for a while.

Syringes for instance. He has a bearlike bulk but he never eats. He's a gathering of things. When that magnet inside him finally stopped spinning and all the things dropped to the pavement for the cops to pick up there was maybe ninety human pounds of him left for the ambulance, according to Henry, who was there, according to Henry."

-Michael Clune, *White Out*.

Sarah Gridley, Nighttown, Cleveland Hts., OH. 2009

"William James, Henry James"

Great gift of purple apples! The distant stars, the far-in sugars

of their skins. With light in certain

shades of the world, *autumn* of limited

use in the world, I could go

for a day

in the word *canteen*.

In the world outside

I have yet to put in. It looks as though the bridges

are standing in aquarelle. You know *propitious*

comes of *going-forward*. Where the horse in mind

unfastens earth, fastens thirst

to a treelike task.

--Sarah Gridley, *Green is the Orator*

AMERICAS

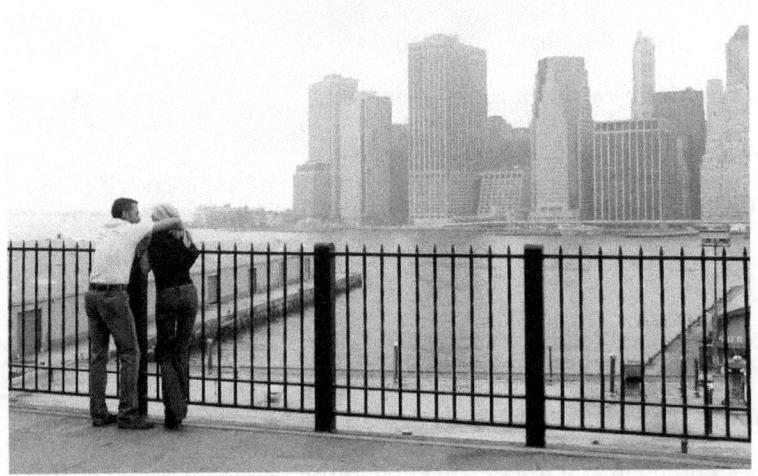

The Promenade, aristocratic old Brooklyn, its cleansing view of the Manhattan skyline, this was the target of my weekend walks in the 1970s. I lived in Carroll Gardens, in the brownstone of Joe and Francie Franco, in the Gallos' neighborhood. When I revisited with my son after 9/11, there was a physical feeling of absence here, like the ghost of Ground Zero, stronger than we had felt the day before at the actual site with all its notes, photos, and tributes. Here was only the calm closeness of the couple, who knew they were a black and white photo, the phantom limb that I felt, outside of themselves.

FAUX FOX

It is 2005 and I'm looking down at the sidewalk, so uneven that the homeless can't even steer their shopping carts. Then I think "Look up, expand your chest, take in the world!" The sort of thing I self-say, a reproach for not living fully, and on my right is this wide-awake ... fox? dog? marmot? ... but the speed of walking New York carries me past the sight that might expand my consciousness, so I whip out my camera and snap this picture from behind.

I should turn around and snap the front too, but someone is bearing down on me, and they might bump into me or pick my pocket. What the hell, I execute a Canal Street U-turn, even though the week before two black police-women gave me a $120 ticket for doing the same in a car -- one said to the other, "He's from Cleveland, isn't that a double fine?" Do you know where this is leading?

No, you don't. Like me, you think this is faux fox, taxidermy, a stuffed renard. But then it moves. No, I don't have a pic of that. There are no pictures of moving foxes, if you think about it. When you see a fox, I mean, it is always on the periphery of your vision. I saw one on *Donauinsel* outside Vienna, a man-made island in the middle of the rushing cold Danube. No way that fox got out there except on the *U-bahn*. The last fox I saw, on my way home from kidney stones at the Kaiser Hospital at 3 a.m., that fox was crossing a four-lane road from the 18th tee of a golf course over to a Jack-in-the-Box.

But you never see the fox in the box.

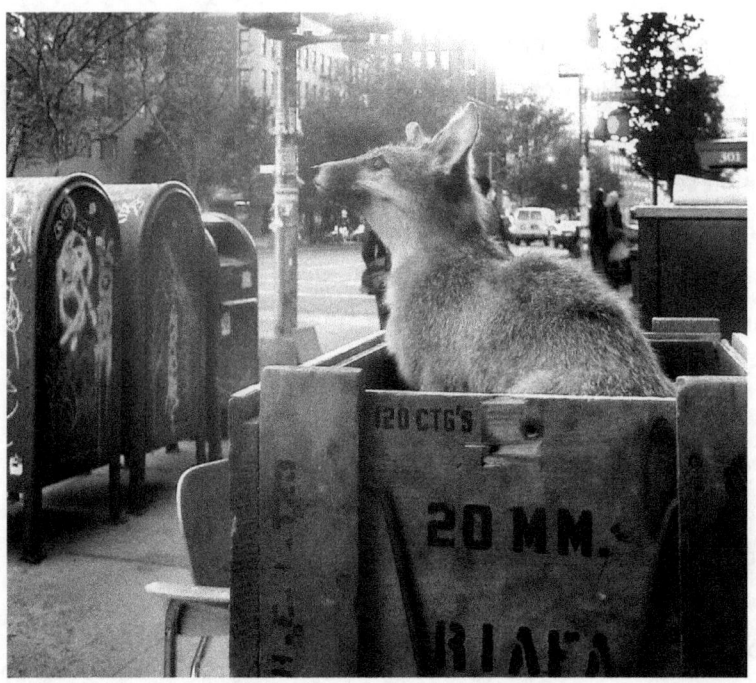

 Let me give you some advice, they say,
 or we all say. But when you're losing,
 no advice finds that handhold on
 your brain, and all the possibles
 look grim. Then the sad cliches
 march out, futures so feeble
 they slip and fall on the tongue.
 "Fight another day" and "learning
 from defeat" and "next year" and

somewhere behind the face of

"Okay," everything is crying

and there's no crevice for

advice to root in. We want

a peephole into fate. But we can't

have that, and can't give it either.

Sitting in my car, the heater blowing,
sitting on my hands, and knowing
the wind will slice me, mince me,
when I open the door to get out --
I hear a sudden crack cross the air,
hammer on copper, one man calling
"Joe, bring up more rivets!"

A hundred feet up, they're working,
black figures on green steeple,
in air that stings my eyes when I
do get out, looking up the white hill.
From some lower level Joe shouts up,
"You want a donut too?

First I wrote: we have green beans,
concord grapes, and tomatoes,
and we're going out of town.
Would you like a delivery?
 And he wrote back:
 We'll eat 'em, for sure!
 When are you leaving?
We might walk over to your house,
our evening exercise, arriving ~8 p.m.?
 We've got kindergarten orientation
 for M tonight, but you can
 leave on front porch (shade)
 or back porch (secure the veggies!)
 if we're not in evidence.
 Alternatively, A and I could swing by
 later today if you'd prefer.
 Just lemme know –
 and thanks for the offer!
My wife says that we will drop by
with the veggies tonight,
because the tomatoes are ripe.
 Got them, and thanks,
 they tasted so good!

What happens when I go for a walk
is a kind of floating in the world,
you might say a stream of being,
only nothing I meet is a metaphor.
Just the opposite – I say I clear my head,
but things and beings approach and
pass in lost choirs of now and then
refusing to be up taken, everything
on a shaky foundation, no under-
standing that does not meet blankness.
What I sought slides along the edge
of vision. Turning toward it
I find the best absence of all,
everything now improvised.

Phrases like salt
of the earth and heart
attack come to mind
when I look at them,
people so natural, so
unassuming that they
seem snatched from
Norman Rockwell.
The best of them in
the Hog Barn at the
Muskingum or
Athens County Fair,
eating cotton candy
or ice cream or riding
the mechanical bull:
life tastes good to them.
It just tastes ... so good.

You going to the demolition derby?

I just ate three pig-on-a-stick!

No bull down in Coolville, just Baptists.

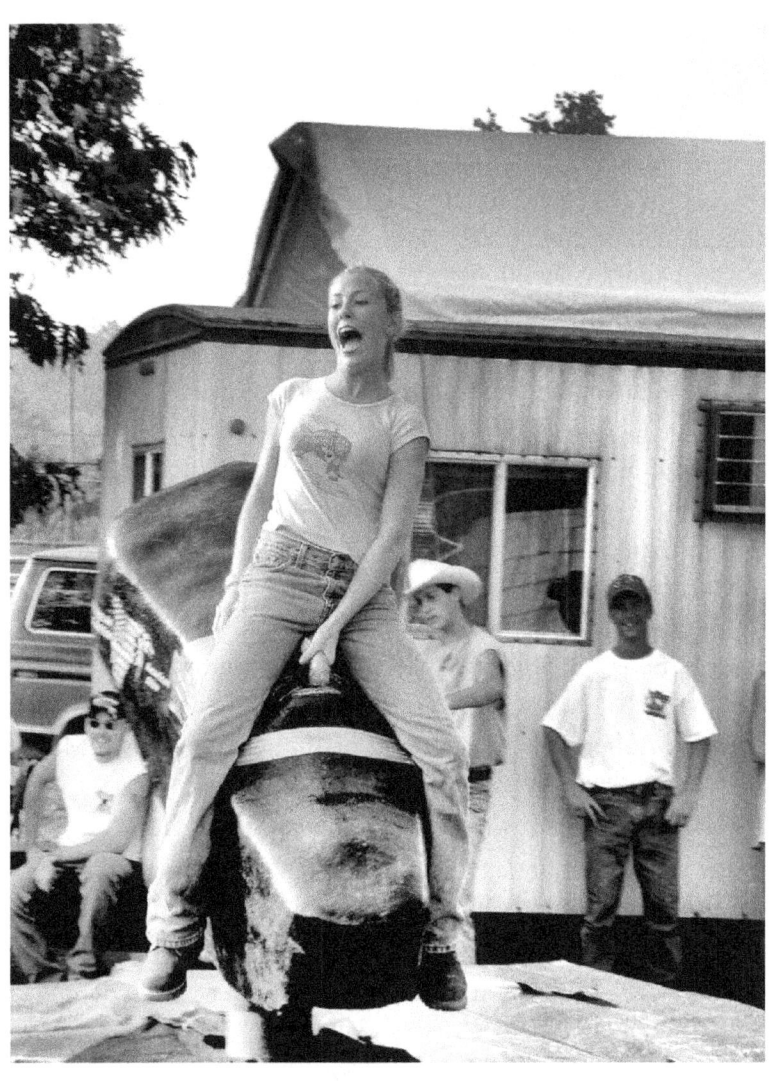

Leslie-Ann married at eighteen,

had two kids by twenty-one—

but it didn't wax her none.

KESEY

Kesey was sitting on the floor with his back against a washing machine, rolling a hash joint with practiced dexterity. This was in Bill Kittridge's basement, I think. We were respectful, awed, especially by the tightness of his roll. He borrowed a lighter, lit it and took two or three tokes. Someone asked him about Cassady. He'd probably answered that a thousand times.

We wanted to hear him talk. "Cassady really liked to drive …. (exhale) … everyone thinks about the craziness, but he really liked to *just drive*, to eat up the countryside with his eyes."

Of course: we all understood.

"At night we would have the radio on, trying to pick up those 50,000 watt stations. In the south XERB from Tijuana, KBAP from Fort Worth. In the north stranger shit, like KSL from Salt Lake and KAQQ from Spokane."

Someone asked if they listened to the Beatles, the Stones, the Grateful Dead. The joint had made a circle and returned to Kesey.

"Those stations didn't play any of that. Johnny Cash, Merle Haggard, Charlie Pride if you were lucky."

"But you had your own music," someone suggested.

"Yeah … but late at night, driving in the West, if you want to be one with driving, you should be listening to the radio … ."

"What about Patsy Cline? Did you ever listen to her?"

"Patsy Cline, ever so fine," Kesey said. "Once Cassady and I listened to a whole hour of Patsy Cline from KBOI — that was in Boise, but we picked it up in Arizona, driving across the Navajo Reservation."

"What was your favorite?"

"I liked them all. But I remember seeing those hogans in the moonlight with Patsy singing 'Crazy' — he sang a bar — "what could be better than that? "

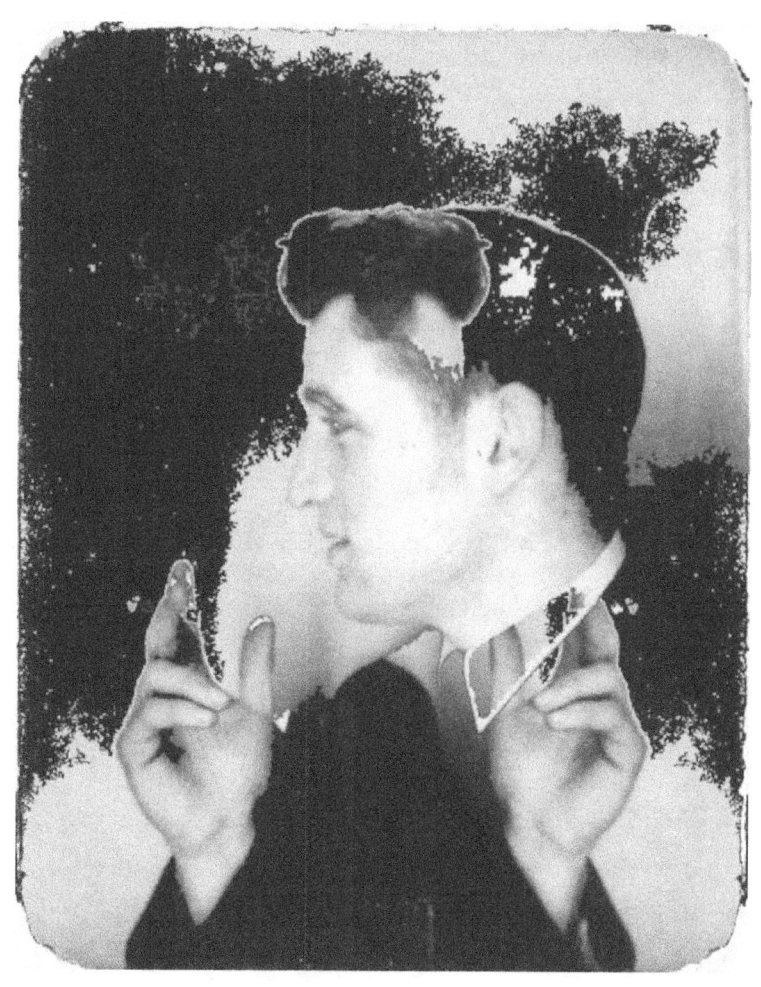

Neal Cassady, double-edged.

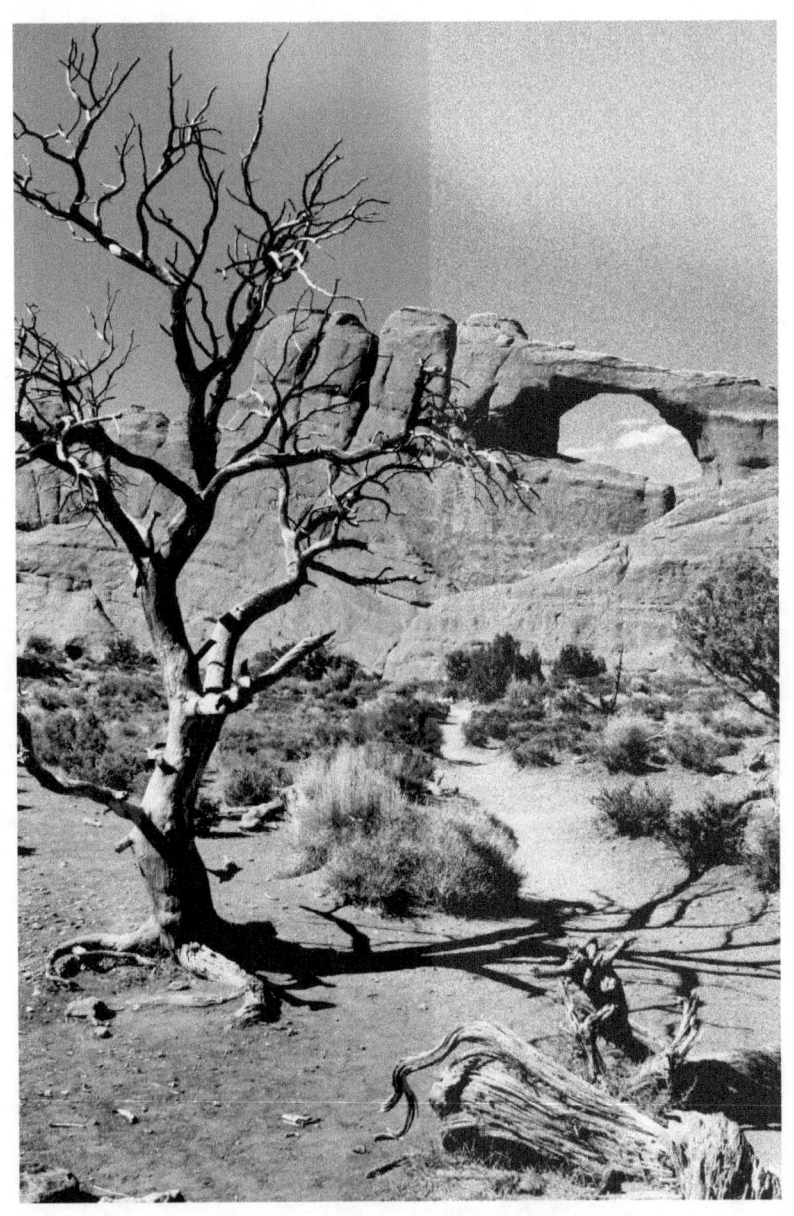

No government to give guidance,

pioneers named places they settled

in Adamic bliss. Calamity Mesa, Hailstone,

and Dandy Crossing. Their poetry lies

all around you at Hite Crossing (named

after Cass Hite, who leveled it, then crossed)

or here at Skyline Arch, or at Mount Tukuhnivatz

(in Ute, "where the sun lingers"). They threw

out the word, and it was the place. Anger, passion,

laughter, irreverence—Goblin Valley, Druid Arch,

Devil's Backbone, Cleopatra's Chair. Lust was constant:

Cohabitation Canyon, Matrimony Spring, Squaw Spring,

and Mary's Tom, where the locals suspected the widow.

Names now corrected by the gov'mint, only old GS maps

showing Mollie's Nipple, the Bishop's Prick, Queen Anne's

Bottom and Son of a Bitch Rapids. But they saved

themselves from Main Street and Goldilocks Lane.

Someone was deceived, there were no saints,

no prisoners, no presidents, no novices or nieces.

Someone has been revised, there are no originals.

Someone let out the mice, there were no traps,

no cats, no ferrets, no boas, no constrictors.

Someone was identified, though no one suspected.

Someone was mystified, she said, there are no sheriffs.

Someone was debouched, debauched, delighted,

But no one worked by antimonies, dichotomies

opposites or opiates or concatenations.

There were no party hats, no apple pies.

They died, were forgotten, and rise again

only in books, and lectures about books.

In my sleep I wrote

a poem about wonder,

how difficult it is

sweeping the mind clean,

keeping in wonder

when the army of fallen

petals distracts me.

I have left wonder

here — I try to

keep it clean, see?

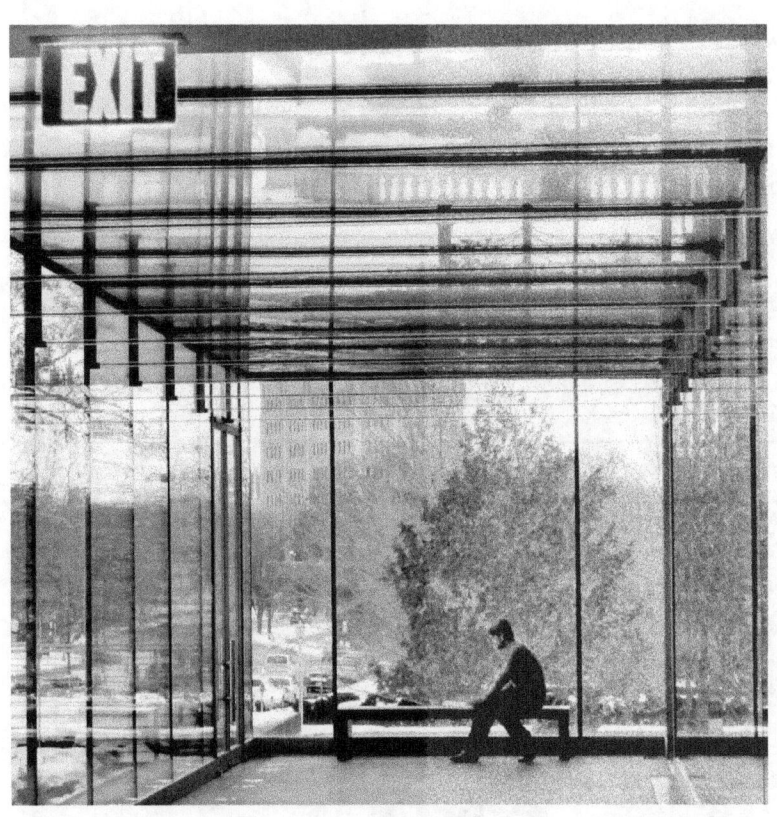

No exit so fine as the one
he didn't know framed him
when he sat down to sketch
the last ocher leaves etching
the trees into the hard white snow.
He was alone, his line against
the grid, his eye against the cold,
his pencil defining now.

In the hospital you hear
the banal and the profound,
clerks talking about soda,
patients talking about the end:
"I was waiting on God today
but he haven't surprised me."
The cheerful old woman in 518
says "I feel fine but I just
don't have any white cells."
The orderlies, the chair pushers
who commute between the street
and the kingdom of doctors
have a courtier's language:
"Have a blessed day!" "How you?"
"I'm blessed. Have a guh'un."
Someone out of my sight says
"I can't put that E-quipo-ment
away, less you want me to."
I enter an ICU room and
I say the Lord's Prayer
for a man intubated, stuck
full of IVs, monitors on
his chest, legs, ears,
he is a purple color.
His lips move with mine.

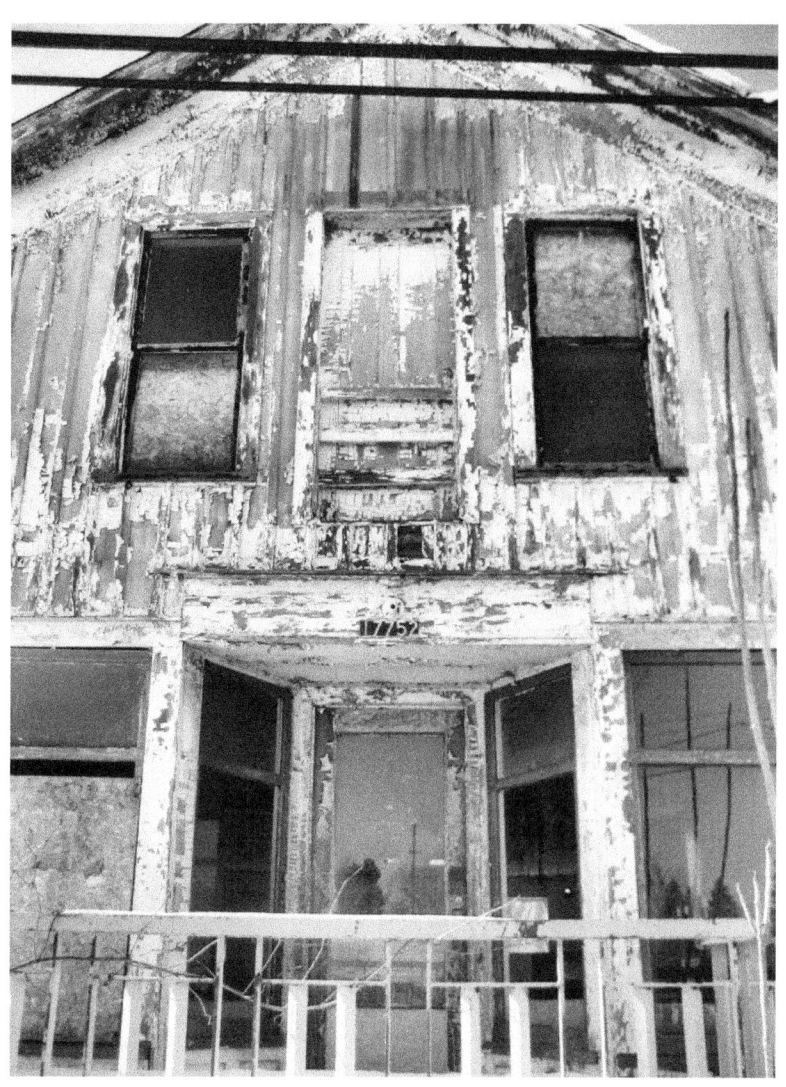

Before I woke up,

I was dreaming about this poem

I even had a rhythm,

with caesuras in the middle —

What was it, something about birds?

I should have risen and written.

I remember editing this poem,

the bird songs outside

changing the punctuation,

which altered the alliteration

and the meaning, as if

coming into consciousness

were the death of meaning.

EUROPE

That last Monet, purple-red
fields levitating between
green poplars pulsating
against a blue sky
well, it grabbed me,
reminded me for the upteenth
time this year how far
off my plan of living closer
to nature I have gone.

I'm in the museum cafeteria —
at the next table a 30ish
American man who is marrying
a 20-ish Russian woman sits
with his American relatives
in a field of red Coke cups
and Saran wrap peeled from
St. Petersburg hamburgers.
"Have you been running?"
asks his dad, a Barry Goldwater
double. Yes sir, he says,
I'm getting fat – that's what
she says. "Elena" – I can see
only the sharp curve of
her Slavic cheek, but he
recalls a young James Caan.

Their wedding is Sunday, 1:15.
I can only think of Poussin's blue,
Claude Lorrain's feathery trees.

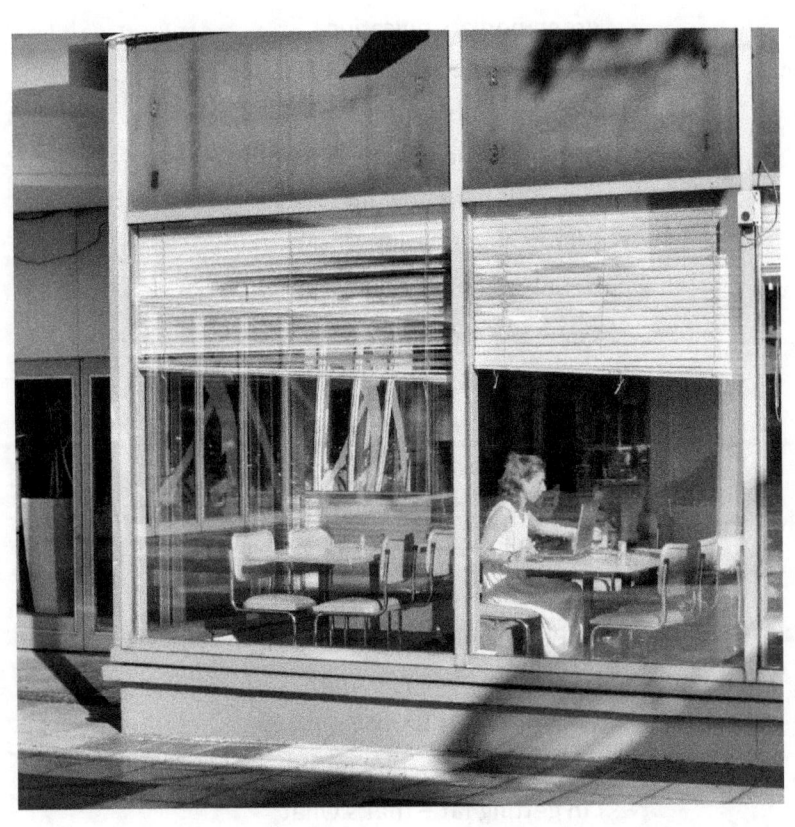

How ironic, Ed Hopper,

to meet you arranging,

deepening this least lonely

Paris. It's not your light,

it's not night, she's no hawk.

It must be the framing

you teach us, how to

remember absence made

manifest at the counter

shared through a window

consumed from the street.

I wonder about them, this Monday
morning, up early going to work
or to school or to the airport?
They don't speak, don't touch,
but they are together, they were
together, her shoes carefully
placed in a corner, his khakis
folded on the chair, everything
prepped for their return to the
voices, documents, social
pirouettes that iron us
flat as tissue paper, that
make our best selves ache.

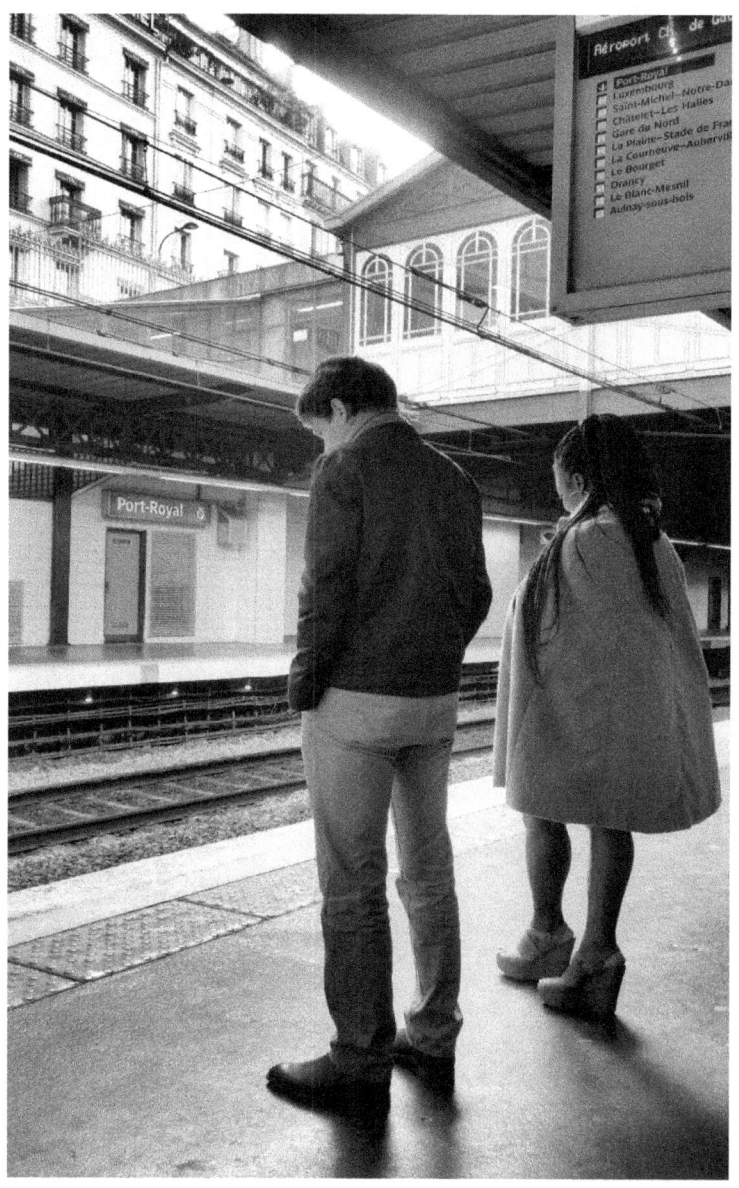

Give us our brood

like we give you brood

don't hold out on brood

and assure us that

after death brood will be

there, like it is here.

I'm serious, I find

brood reassuring.

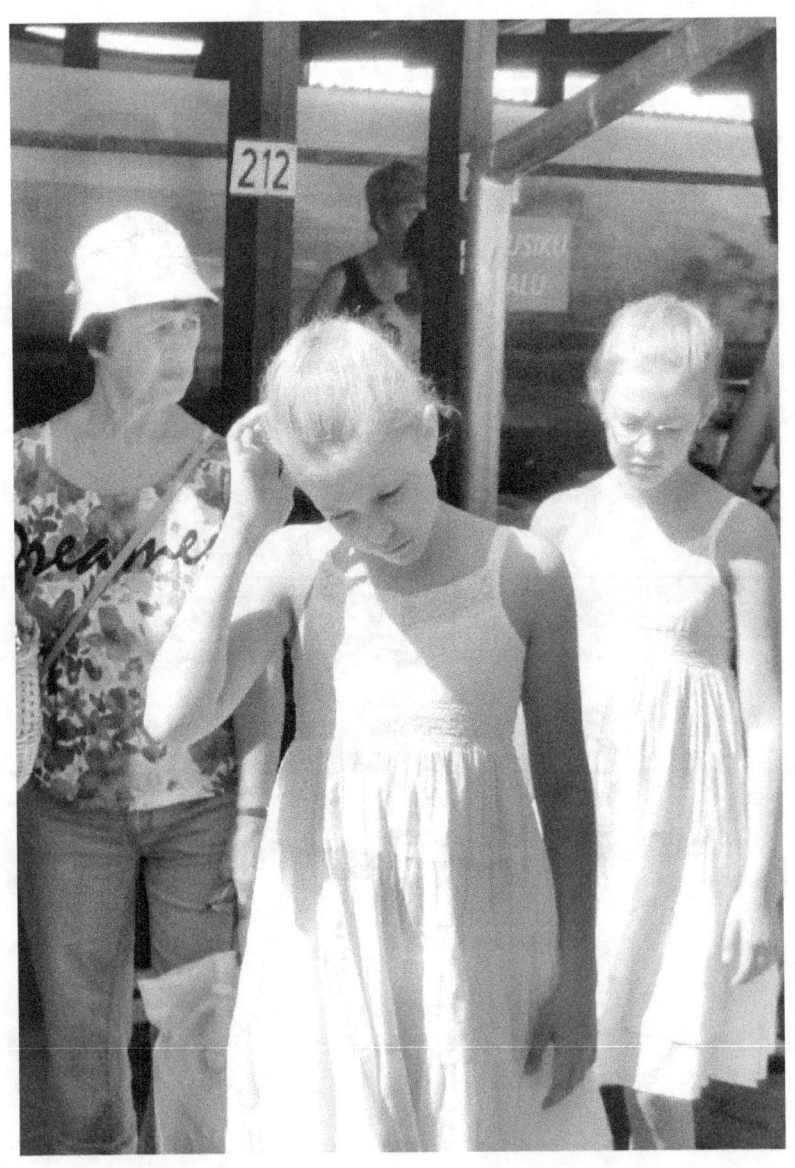

Into the Tartu morning
slowly, sometimes it is
necessary to come,
from an angle,
not to insist that work

begin before the swallows
glide and dive after bugs.

Often it is better to wait
for the caffeine or nicotine,
the sugar or the wet nuzzle

that calls forth our biology.
Usually that crease finds us,
spills us into our sun-waking.

Ladies, I know
you don't roll over
into morning and
feel a rough face
like I do, but
how do you look
so good so early?
You're like flashing
coins sinking away
from me on the street,
your eye-liner, lipstick
and I don't know what-all
applied immaculately —
how long does it
take? You make me
feel like a lazy leaf
in yesterday's puddle.

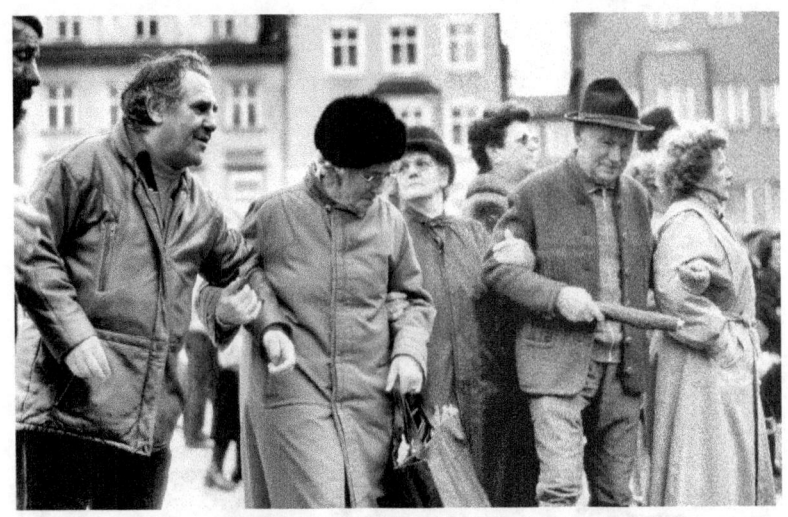

It begins at 11:11 on November 11. The weather isn't great that time of year in Bavaria, but the tradition of talking back to rulers, the parody of pomp, the election of the Lord and Lady of Misrule have been deeper than weather since the Middle Ages. The good burghers dye their hair, get pink and blue and baboonish. No part of Germany seems as complex as Bavaria, which for a prosperous region acts strangely put upon. "We're Catholic and Greens and traditional," yet everyone seems to drive a Mercedes, even as a second car, and only students drive Volkswagens. Well, this was 1987, when I didn't speak any German and had come over from Paris to see a friend, who drove an Opel she called Oscar.

Then they started to dance, the older people, dusted off their soulfulness. People who waited for the walk light to turn green, always, who never gave to beggars, whom they could only

imagine. But it was slow, and it was raining. I was getting impatient with this much hyped Fasching and complained to my friend. "Just be patient," she said.

And then these guys danced out – very somber and serious, like killers in tutus.

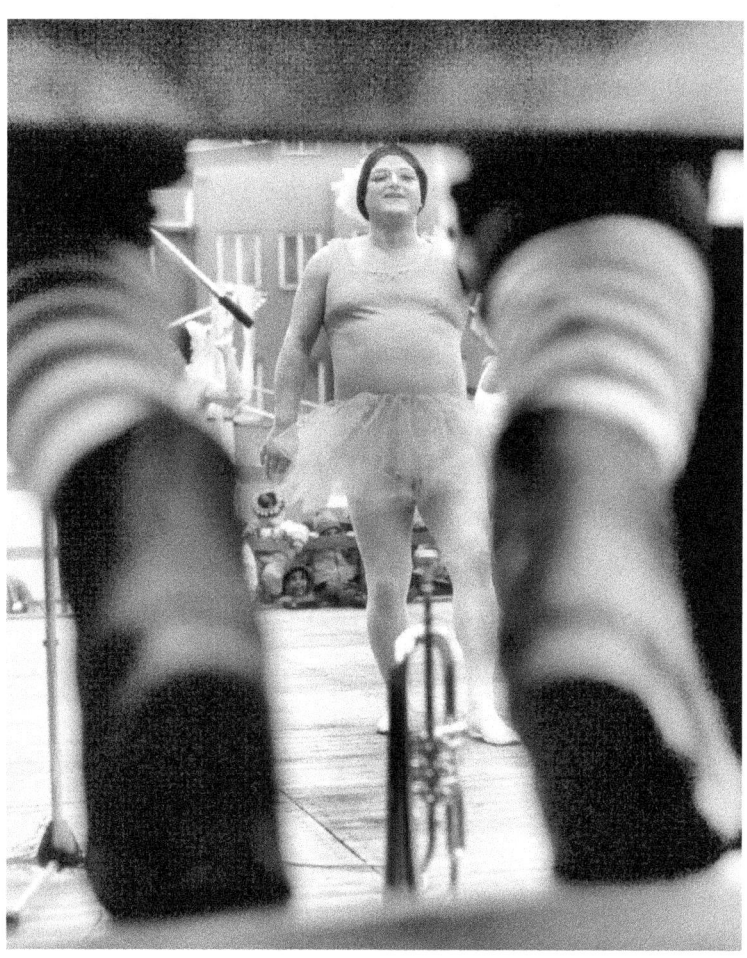

I heard on the radio that Lemond had gone off the front but was slowing enough for Hinault to catch up. Then they came into view together and blew past me surprisingly fast -- but I could see that Hinault was suffering. Later, in *L'Equipe,* I read that the prodigal American pulled his team leader up the final 28 switchbacks of the fearsome L'Alpe d'Huez and that they crossed the finish line hand in hand. I didn't see that. I had left Grenoble early in the morning and walked down from the ski resort, where the bus deposited me, to this curve, where a dozen Dutchmen had parked their motor-homes and were waiting for Joop Zoetermelk, whose named means 'sour milk.' It's written on the road under Hinault's front wheel.

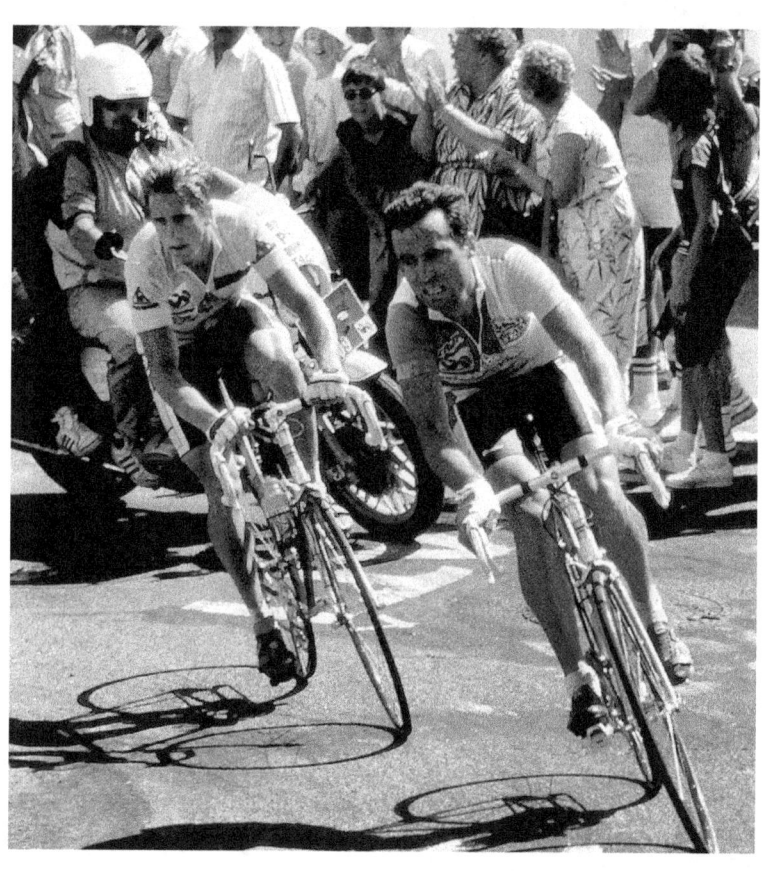

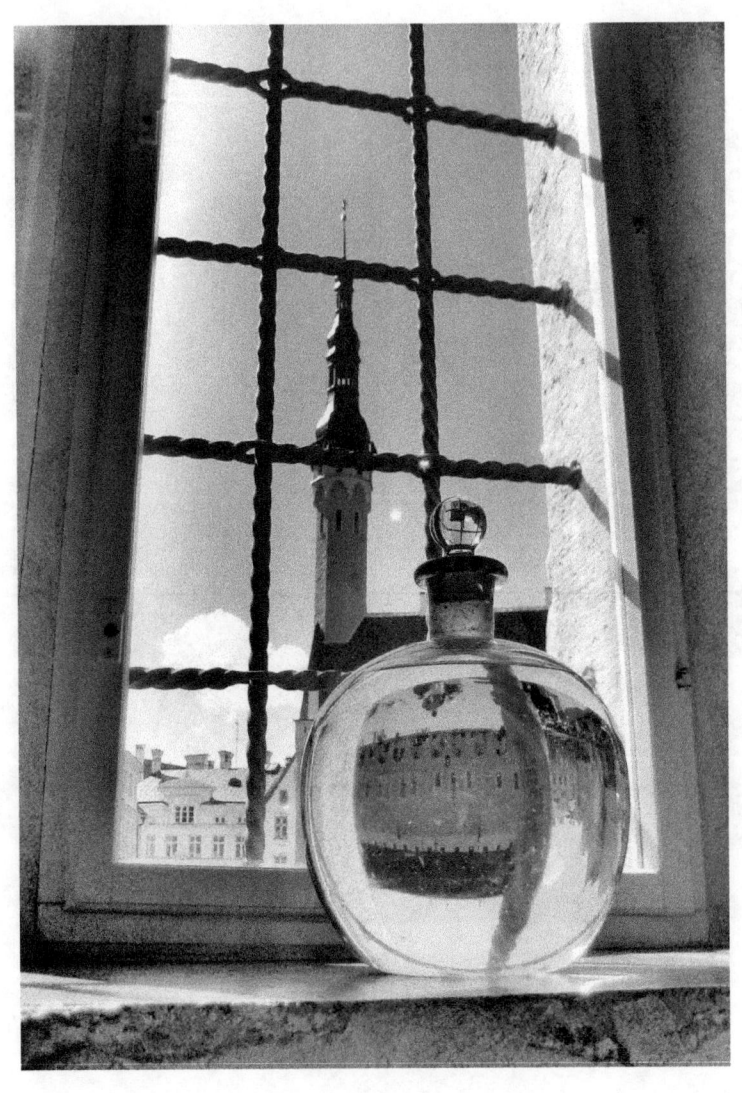

Wooden cabinets and high ceilings

in the Tallinn town hall pharmacy:

You remember Copernicus and Occam,

but you can still buy a bandage

or Sudafed here, if your nose is running

and you're waiting for this woman

who might be the one, waiting in

a pharmacy that has operated

on this spot since the 15th century,

and then you see the town hall

upside down in the bottle, even

in the stopper, and you think

even colds have an upside.

PERSONALLY

This friend of mine, two decades ago, claimed that she went to Peter B. Lewis' condo, and he had Peter Max' paintings in his bathroom, two of them, one in front of each toilet. She thought that was *faux* kitsch. But I liked his chutzpah and since Lewis, founder of Progressive Insurance, was himself a Hemingway kind of character, right out of *The Sun Also Rises*, that story gave me this idea, Young Hemingway done to the Max

I was also reading Henri Michaux then, his asemic line drawings, so I did Hemingway again with a page of manuscript from the same book, in which Jake describes first meeting Pedro Romero. Between them, it's a kind of love story. If you get down in the words, the strike-outs, you can see a romance.

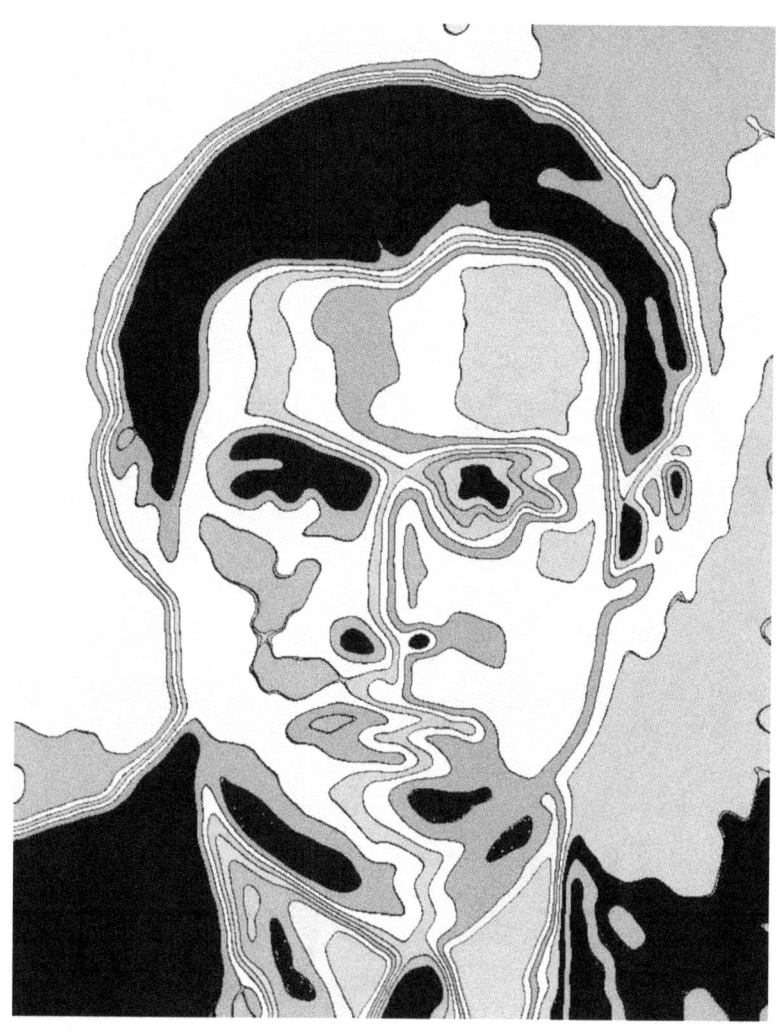

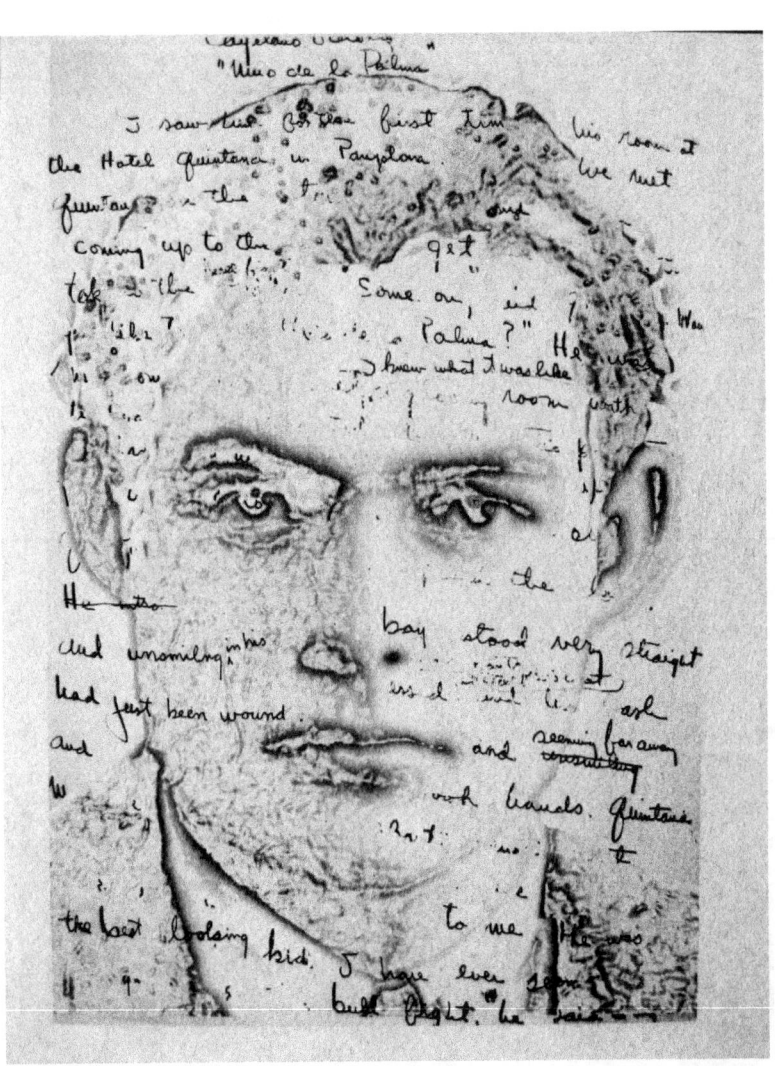

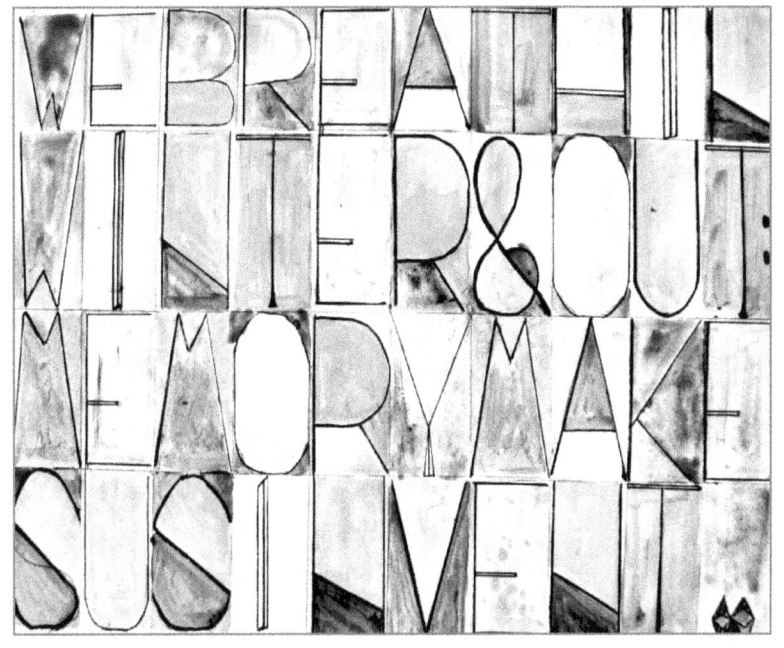

We breathe in

winter & out:

memory makes

us invent.

It was just one of those days,
the dog wouldn't start and
the basement flooded before
it rained. I threw open the
windows and mosquitoes left
the house. Trees fell down,
got up, walked away indignant.
So I moved into a hotel
looking for a lover, but
all I got was a lousy mime,
now every time I look in
the mirror he's looking
for an older woman, there's
just no chance of penguins
when life gives you squirrels.

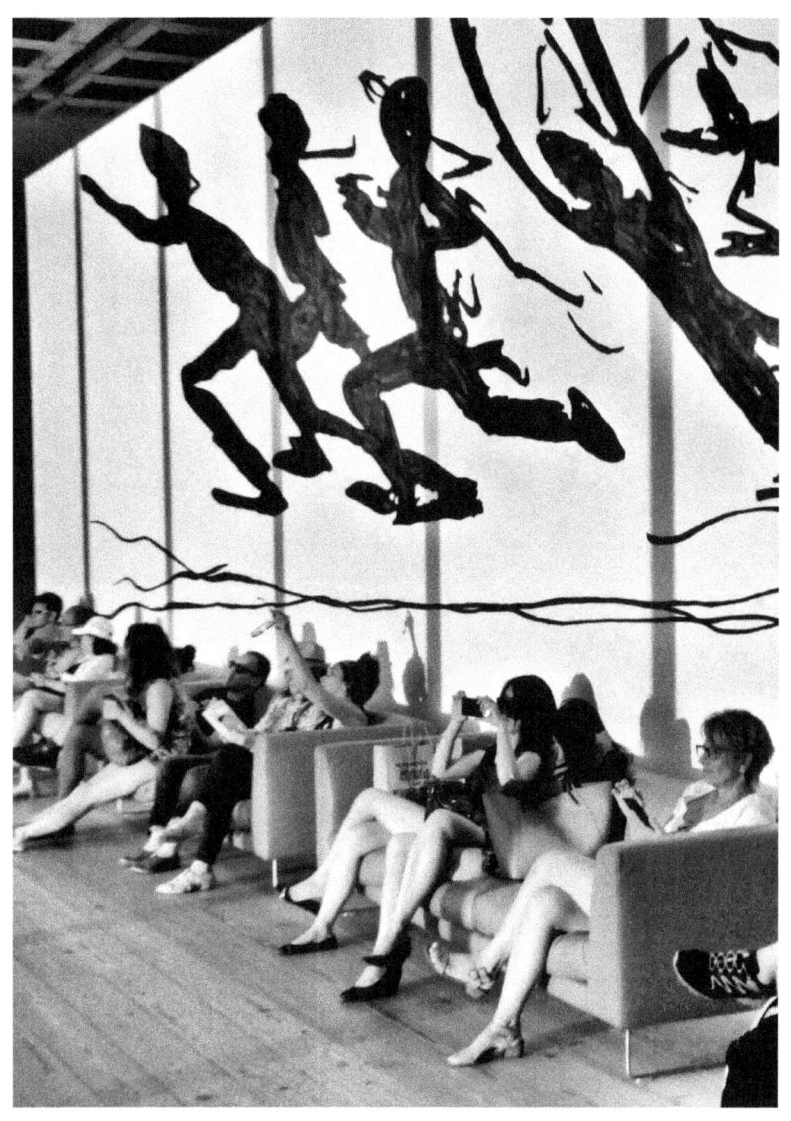

It was the first Christmas
after I was hit by a car.
I could finally walk again
without crutches, and then
it snowed, so I had to think
about slipping and falling.

www.ingramcontent.com/pod-product-compliance
Lightning Source LLC
Chambersburg PA
CBHW061442180526
45170CB00004B/1520